May 1, 1997

To my Beloved Floyd who
exemplefies the love of
our Saviour consistently
to me everyday.

To my Beloved Floyd who
exemplefies the love of
our Saviour consistently
to me everyday.

Seven Encounters with...

THE SAVIOUR

Written by
R. KENT HUGHES

Paintings by
RON DiCIANNI

CROSSWAY BOOKS • WHEATON, ILLINOIS
A DIVISION OF GOOD NEWS PUBLISHERS

From the Author

To Rev. Verl Lindley, who first introduced me to the Saviour over four decades ago.

—*R. Kent Hughes*

From the Artist

In memory of my grandmother, Mary,
who was the first to show me the Saviour.

I wish to express my gratitude to Lane and Kent for including me in this project.
Noplace will I be more honored to have my name appear than on a book that bears the title *Saviour*.

—*Ron DiCianni*

The Saviour

Copyright © 1995 by R. Kent Hughes

Illustrations by Ron DiCianni

"The Promise" calligraphy by Timothy R. Botts

Published by Crossway Books
 a division of Good News Publishers
 1300 Crescent Street
 Wheaton, Illinois 60187

Many thanks to Robert Owen Roberts of Richard Owen Roberts Booksellers, Wheaton, Illinois for generously sharing his time and expertise in fine and rare books.

Interior backgrounds: David Voigt

Digital Imaging: Raymond J. Elliott

Art Direction/Design: Mark Schramm

First printing, 1995

Printed in the United States of America

Scripture taken from the HOLY BIBLE: NEW INTERNATIONAL VERSION ®. Copyright © 1973, 1978, 1984 by International Bible Society. Used by permission of Zondervan Publishing House. All rights reserved.

The "NIV" and "New International Version" trademarks are registered in the United States Patent and Trademark Office by International Bible Society. Use of either trademark requires the permission of International Bible Society.

The publisher wishes to acknowledge that some of the material appearing in chapters 3, 4, 6, and 7 is adapted from R. Kent Hughes's commentaries, *Mark, Volumes I and II, Jesus, Servant and Savior.*

Library of Congress Cataloging-in-Publication Data
Hughes, R. Kent.
 The Saviour / written by R. Kent Hughes : paintings by Ron
DiCianni ; calligraphy by Timothy R. Botts.
 p. cm.
 1. Jesus Christ—Biography—Devotional literature. I. DiCianni,
Ron. II. Title.
BT306.5.H84 1995 232.9—dc20 95-23642
ISBN 0-89107-853-3

03	02	01	00	99	98	97	96	95						
15	14	13	12	11	10	9	8	7	6	5	4	3	2	1

CONTENTS

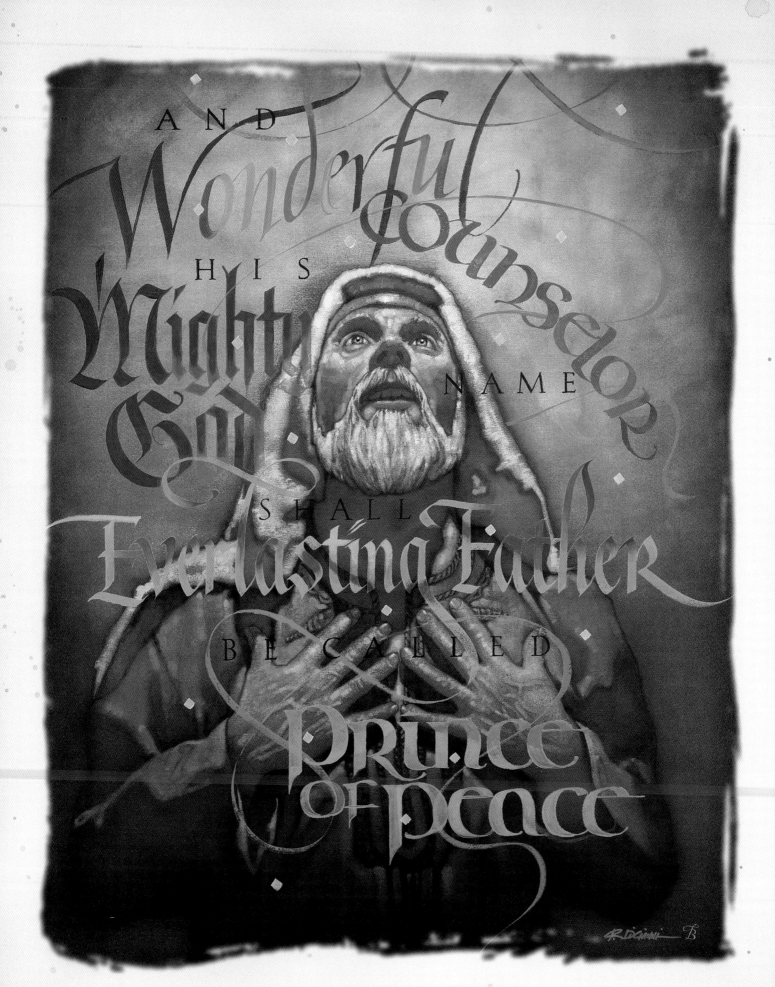

AND

Wonderful Counselor

HIS

Mighty God

NAME

SHALL

Everlasting Father

BE CALLED

Prince of Peace

THE PROMISE OF THE SAVIOUR

DO WE REALLY NEED THE SAVIOUR? Do we really need a "Wonderful Counselor, Mighty God, Everlasting Father, Prince of Peace"? Will you let me share a personal story with you? Though I would rather not focus on my own experience, nevertheless there are times when God does such a work in one's life that it is a sin to remain silent. And although what I have to share is in the first person, it really is a story about God. May all the glory go to His name! ¶ It was only supposed to be routine surgery, but something went wrong. And the life of my beloved wife, Barbara, hung in the balance by the thinnest thread.

Early in the morning I had checked Barbara into the hospital and settled back to wait. As I was reading the morning paper, I recognized a medical technician named Suzanne and cheerfully greeted her. Suzanne had become friends with my wife's niece when they both had worked in the hospital some years before. Barbara's niece had long since moved away, and it was quite unexpected to run into Suzanne—especially since she normally didn't come to the waiting room area where I was sitting that morning.

5

My oldest daughter, Holly, joined me, and at 10 A.M. the surgeon met with us and cheerfully announced that everything was "perfect, it couldn't have gone better." Barbara would be in the recovery room for an hour and a half, and then I could see her. So Holly and I agreed that I would go home, do a few chores, and we'd see Barbara together a little later.

But when I returned, I was met by my worried daughter who informed me that they had taken Barbara back into surgery. It was only supposed to take fifteen minutes, but those fifteen minutes stretched to five hours. We soon realized something was seriously wrong. They couldn't stop the bleeding, and no one on the team of doctors could figure out why. The day stretched on into the evening without any answer.

Thus began a very long, dark night. Barbara sensed her life was slipping away. After her doctor's visit at 11 P.M. matters only worsened. Nurses repeatedly changed the dressing, but Barbara continued to hemorrhage and kept growing weaker. At 1:30 I called our associate pastor to start a prayer vigil, and I got more than I'd asked for as all the staff and several friends arrived within an hour to pray.

By the middle of the next day, however, it looked as if I was going to lose my beloved wife. By then she had lost two-thirds of her body's blood. Her heart was racing, and she kept bleeding. As family members gathered around the bed, Larry Fullerton, my associate pastor, commented, "You need to encourage her. She thinks she's going to die. Her blood isn't clotting."

Remember Suzanne? She had seen me the previous morning and now happened to stop by at just that moment to say hi and give Barbara some magazines. Shocked to walk in on a family crisis, she felt like she really shouldn't be there, but stayed long enough to hear Larry's comment about "her blood not clotting."

In that instant Suzanne remembered doing a blood test years ago on Barbara's niece. When she had showed the results to a blood specialist, the niece was warned that if she were ever in a car accident or suffered a similar trauma she could bleed to death. Suzanne ran to the lab, switched on her computer, called up the niece's records, and compared them with Barbara's work-up; the pathology was identical! Suzanne then ran to the critical care unit and tried to explain all this to the nurse. She then dashed back to her supervisor, who told her to go immediately to the blood bank. As Suzanne began to explain, the blood bank doctor exclaimed, "Barbara Hughes! Tell Dr._____!" Barging into the doctor's meeting with five pathologists, Suzanne told her story. Within the hour Barbara was given the medication for her rare blood disorder—and her life was saved.

But this is not a story about Barbara or Suzanne. It is a story about God. What happened to my wife and Suzanne is a miracle of divine providence. There is no other way to explain it. It really started years ago—when two bored lab technicians ran tests on each other, and one (Suzanne) learned that the other (who happened to be my wife's niece) had a rare clotting disorder. Then on the day of Barbara's surgery, I ran into this lab technician—who normally doesn't come to the area where I was—and mentioned Barbara's surgery. The next day Suzanne stopped by to see Barbara at exactly the right moment to overhear Larry's comment. Amazingly Suzanne remembered those tests from years ago.

Suzanne saved my wife's life. But was it really Suzanne who saved Barbara? No. God did! It was God in His sovereign care who orchestrated the miraculous details of these events. But I would also say that if God had taken Barbara home to be with Himself, He would have been just as involved in the events of the day and just as faithful in His sovereign care.

How awesome God is. How He is to be praised above all else. How adequate He is in life and death—our "Wonderful counselor, Mighty God, Everlasting Father, Prince of Peace."

Where would we be without the Saviour? In desperate need; more than this, eternally lost. That is why the promise of the Saviour—given to Isaiah centuries before the birth of Christ—is so powerful. The glorious truth is that God knew our desperate need in eternity past, and He created the perfect "gift list" to meet our need. As God revealed to the prophet Isaiah:

> For to us a child is born,
> to us a son is given . . .
> And He will be called
> Wonderful Counselor, Mighty God,
> Everlasting Father, Prince of Peace.

Here is the ultimate gift list—perfectly crafted by our loving Father—for every day of our life. A Saviour would be born—One who would live a perfect life, die for our sins, and conquer death and who will return in power and glory to reign forever.

Who is this Saviour? The gift is first described as "Wonderful"—or more literally as "Wonder." The coming Messiah will be more than wonderful, for He Himself will be a *miracle*.

This is *the* word for the Incarnation. When the shepherds came and gazed on the Christ-child they saw a miracle. What lay before their dazzled eyes was the union of

God and man in a single being—the very "mystery of godliness"—a wonder! Though Christ was "before all things," though "all things have been created by him and for him," though "in him all things hold together," He became an earthling. As long as eternity lasts, this wonder will amaze us. "Wonder" is the Saviour's eternal name.

The wonder of who Jesus is becomes all the more amazing when we understand that He is literally our "Wonder-Counselor"—our "Miracle-Counselor." Who could know us better than Jesus? He is the one who knit us together in our mother's womb. He knows our every thought and feeling. Our souls are open books before Him. And yet He *loves* us unconditionally, with an everlasting love. He cares for us more than anyone could ever care. He gave Himself for *you*. He prays in heaven for *you*. As our "Miracle-Counselor," He knows our deepest needs and offers us His eternal wisdom and loving care for our lives.

The first gift on God's "promise list" is a Counselor who is nothing less than Wonder. This is a gift to make the soul sing.

The next gift is "Mighty God"—literally "Mighty Hero God." Jesus is our divine hero warrior!

How could Jesus become our Hero? This became possible only when He became man, setting aside His eternal knowledge, power, and glory. For thirty-three years He stood against temptations more numerous and terrible than man has ever known. He stood against all the shafts of Satan; not one arrow from the quiver of hell was spared. Christ conquered every time. He is our conqueror forevermore—our Hero.

See His heroics in the Garden of Gethsemane. On the eve of His death He looked into the cup He must drink and was so horrified that He said, "My soul is overwhelmed with sorrow to the point of death."

See His heroics on the Cross. There the heart of Jesus became like a reservoir, where the streams of iniquity and every drop of sin ran down and gathered in Christ's heart—like one vast lake, deep as hell and shoreless as eternity. And yet He endured them all. Our Mighty Hero God.

See our Hero in the sky. Today in heaven He wears His battle-scarred, glorified body in eternal witness that He is our Mighty Hero God. His gift to us is this: nothing is too hard for Him. He can deliver us from every sin and every situation that binds us. He saves to the uttermost (Hebrews 7:25). And for those of us who are His children, there is nothing He will not do to help us in our need. Our Hero's promise remains constant: "He who did not spare his own Son, but gave him up for us all—how will he not also, along with him, graciously give us all things?" (Romans 8:32).

The third gift is "Everlasting Father." There is no contradiction here. Though Jesus is God the Son, He still relates to His own in a Fatherly way. When Philip asked Jesus, "Lord, show us the Father," Jesus answered, "Anyone who has seen me has seen the Father." And when we know the Saviour's Fatherly love for us, our hearts cry out to God, "Abba, Father."

Because He is our *Everlasting* Father," we know that His Fatherly care for us will never cease. When our time here comes to an end, we will know His Fatherly care in a new and deeper way—for all eternity. How beautiful is His title, "Father." It says, "Come home" to all who know the Saviour.

Lastly, Jesus is our "Prince of Peace." How fitting were the angels' words—"peace on earth"—at Jesus' birth, for the Prince of Peace had come. He was the sovereign giver of peace. For thirty-three years He lived a life of perfect peace. And in the Upper Room, on the eve of His death, He said, "Peace I leave with you; my peace I give you." Then as He was stretched forth on the Cross, the prophet Isaiah tells us, "the punishment that brought us peace was upon him." On the Cross He paid the price for our peace. As the risen, living Saviour, He declared to His own, "Peace be with you." He is the sovereign King of Peace.

What a Saviour was promised! What a Saviour has come! What a Saviour will come again!

As the life of my beloved wife hung in the balance, I saw as never before that our only hope is in our sovereign Saviour. But not just for Barbara and not just for me. He is the only hope for everyone. Apart from the Saviour we all are desperately lost. What a beautiful thing it is to know the Saviour—our Wonder-Counselor, our Mighty Hero God, our Everlasting Father, our Prince of Peace.

The story of the Saviour is the story of this book—the story of the One who calms the storms of life, who opens our eyes to eternity, who meets our deepest need, who washes away our sins.

Do you long to know the Saviour? May you meet Him in these pages. The promise is for you.

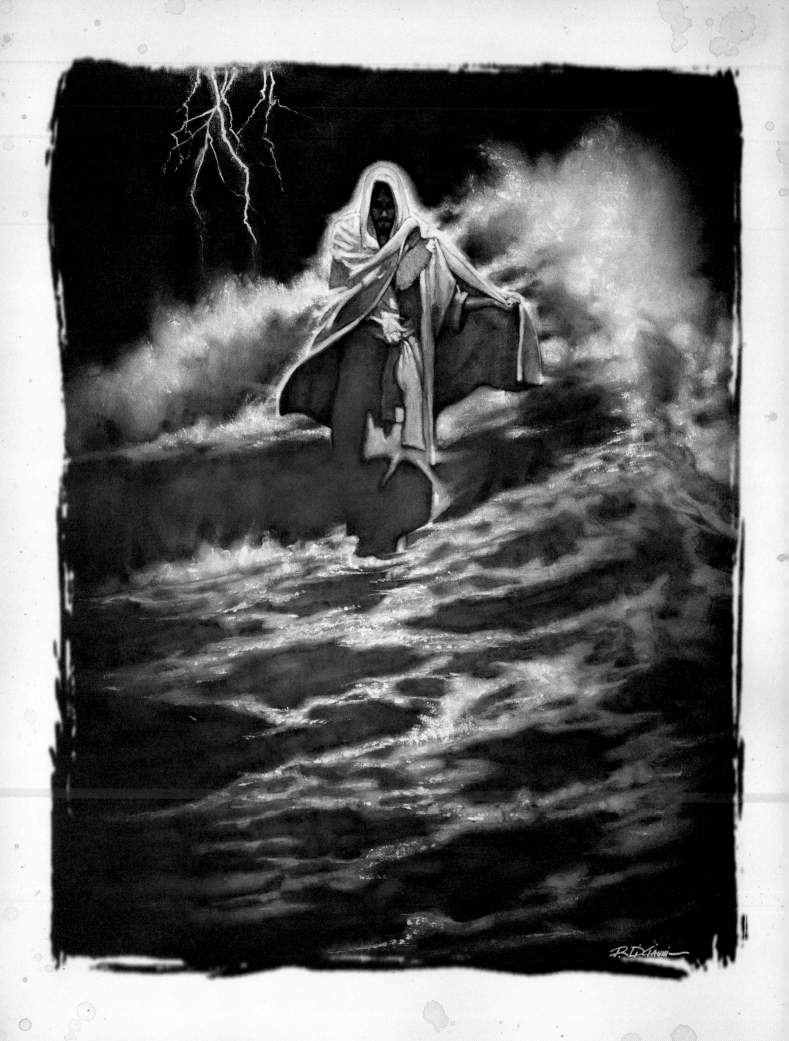

THE SAVIOUR AND THE STORM

WITHOUT WARNING THE WINDS had come, sweeping off the Mediterranean Sea, down through the Kishon Valley, churning the Sea of Galilee into a violent tempest. Tossed about in their tiny skiff, in the darkest hour of the night, the disciples feared for their very lives. ¶ It certainly was not what they expected. Do you recall the circumstances? Just the evening before, Jesus had miraculously fed the 5,000. The response was dramatic. With their stomachs filled, messianic fervor swept through the crowd, and they sought to make Jesus king by force.

What a tremendous opportunity, the disciples surely thought. Why then would Jesus *force* them (for this is what the text in Mark means) into their little boat, push them out to sea, and abandon them to the storm? And why was He not there in their hour of greatest need—instead praying on a mountain by Himself? Did Jesus really know their need? Did He really care?

How natural the disciples' terror was, for there are few things more frightening than a raging storm. The power of the sea can be awesome in its destructive force. Unsuspected, it can overwhelm even a mighty ship like the famous *Edmund*

11

Fitzgerald—some three football fields long—and snap it in two, plunging ship and crew into a grave of icy waters. If the fear of Jesus' followers was only natural, the answer to their fears could come only from beyond the natural danger that threatened to sweep them away.

How like the disciples we so often are. The storms of life sweep in. Fears begin to rise. We wonder if the Saviour knows. We wonder if He really cares. And because we *are* so like them, the Saviour's care for His disciples in their storm-tossed boat becomes a beautiful picture of His care for His own today as we face life's threatening storms.

First, we need to see that this is a story of faith and the test of our faith from beginning to end. Jesus *made* the disciples get into the boat. He literally *compelled* them to go. The picture that Scripture paints is that the disciples did not want to go over to the other side. They had to be persuaded. Jesus deliberately sent them out into the lake for a purpose they did not understand.

Can you see the disciples making their way across the Sea of Galilee, the waves battering their little boat? The winds buffeted them head-on, tossed them about, and drove them back. What terror they felt. As one great preacher described the scene:

> Peter, no doubt, took command . . . you can see him there holding the tiller with his stalwart arm, and his beard anointed with the foam of the sea. [In anxious] tones he commands the disciples to trim the ship, lower the sails, and take to the oars. Where all was calm a little while ago, now all is tumult and confusion. As the tempest rages over the lake, the ship tosses like a cork up and down in the great waves, the white foam of the great rollers gleaming in the blackness of the night like the teeth of some monster of the sea.

They were in trouble! But wait. Why were they in trouble? The answer is clear from the text: because they *obeyed* the Lord; because they pointed their boat against the winds at the Saviour's own command. Remarkably, if they had *disobeyed* the Lord they would have avoided trouble. Their obedience only brought the raging seas. Can this be so?

What is the deeper truth in this? Our Lord is saying, "Those of you who have decided to follow Me are going to be sailing your vessel into the hostile winds of the world. You are going to have trouble." It is inevitable that we will have storms. All who give their lives to Christ will face the contrary winds that seek to shipwreck them. But there is a marvelous teaching here. Moses would never have known rejection and terrible hardship if he had disobeyed the voice of God when He spoke

from the burning bush. Daniel would never have faced the lion's den if he had bowed his knee to a pagan god. Paul would never have been jailed and stoned if he had spurned God's voice on the Damascus Road. But neither would these great men have known the winds of the Holy Spirit filling their sails or felt their "ship" propelled by God Himself.

The storm was raging. The waves were immense, dashing over the ship. The masts began to crack, and water sloshed into the dark hold of the beleaguered boat. The situation did not look good. The disciples had to wonder, "Has Jesus forgotten us?"

No, the Saviour had not forgotten them. Mark's gospel says, in fact, that Jesus "saw" them even though it was dark. Was it in a momentary flash of lightning? Was it by divine omniscience? Certainly that is possible. But no matter how He saw, the point is that He *saw* them and He *knew* what they were facing. In this dark age, life can be so tossed by the hostile winds of the world that it sometimes seems as if the Saviour has forgotten us in the storm; but He has not. He sees, and He knows. As Psalm 139 tells us,

> Where can I go from your Spirit?
> Where can I flee from your presence?
> If I go up to the heavens, you are there;
> if I make my bed in the depths, you are there.
> If I rise on the wings of the dawn,
> if I settle on the far side of the sea . . .
> your right hand will hold me fast.

Wherever we go, our Saviour is there, and He knows all the details. If you are going through dark storms, it is easy to think He has forgotten. But He sees, and He knows. If He knows even when the sparrow falls to the ground, how much more He knows the difficulties you and I are going through.

When did Jesus come to their help? Mark says, "about the fourth watch"—in other words about 3 A.M., in the darkest hour of the night. The disciples were exhausted. They were miserable and tired, wondering if they were going to survive. Only then did the Saviour come—in the moment of their greatest need.

Have you ever experienced the same thing—the check that came in the mail at the last minute, the house that sold at the eleventh hour, the answer that came when all seemed lost?

I remember well experiencing that "fourth watch" timing when I was in college. During my senior year we were expecting our first child. It was a difficult time in

our lives because I was so busy. I was working full-time in a factory and taking a full load in school. All I was taking home was $73 a week for full-time work. It was two weeks before our child was due. I had calculated that by the time of Barbara's delivery I would have $160. But the doctor wanted $250, and the hospital another $250. I knew I was going to be far short. So we prayed. It was the eleventh hour all right.

Well, our baby came. But before that, something happened. When Barbara went for her final examination, the doctor looked over the charts and noticed for the first time that I was studying for the ministry. The doctor had no Christian background and was not interested in such things, but he said, "I am not going to charge you." Great! Now we only owed $250 to the hospital!

When I went to the hospital to pick up our daughter, I was going to bring her home no matter what they said. Though I had only $163, I was determined to put that down and walk out with my baby. But do you know what happened? Our timing had been just right. We had only been charged for two days instead of three. The bill was $160. I had $3 left over to buy flowers for my wife! You see, Jesus came to us in the dark part of the night, when we had been toiling and were afraid about what was going to happen. What a wonderful surprise!

When Christ comes to us in the midst of life's storms, why are we so surprised? Here again how much we are like the disciples. "When they saw him walking on the lake, they thought he was a ghost. They cried out, because they all saw him and were terrified." Perhaps this is understandable. It was dark, the wind was howling, they were barely hanging on to their lives. Through the misty sea spray they saw a figure coming across the water. The disciples were ready to dive overboard.

But should they have been so surprised? Did they not remember the miracles? Did they not remember who Jesus was? Was it too much for the Creator of all things to walk upon the seas He had made? Did they not understand that Jesus would not abandon them in their distress?

Why did they not recognize the Saviour? Because they were not *expecting* to see Him. So it is with us. So often when Christ comes to us in the hour of our need, we reject Him because we do not believe He really will come to our aid. We think He can help *others*, but that He is unaware of *our* situation and is powerless to help us. Or in the perverse pathology of our hearts we may even reject His help because it does not come in the way we expected. And so we push away the very hand that would heal us.

Though we are so often like the disciples, it is amazing to remember Jesus' response. He comes to us—despite our fear and doubts—with His voice above the storm: "Take

courage! It is I. Don't be afraid." And when we truly hear His voice, all is changed. Some, like Peter, even have the courage to take unthinkable steps of faith. The winds cease, fear is banished, and we, like the disciples, welcome the Saviour into our storm-tossed life.

Following Christ will certainly bring us into contrary winds. This is the lot for all of us. That is a promise. But be comforted—He knows all, He sees all. He understands our troubled thoughts, and He loves us better than any other ever can. What a beautiful truth!

Are you facing life's storms right now? Remember, He sees. Believe that, rest in it, take hold of it. Rejoice that the Saviour's gracious help is on the way before you even see it.

Are you filled with darkness? Do you wonder if there is a way out? If you look to Him, expect Him to come, because He often comes in the fourth watch. Be wise, and do not reject Him when He comes. Focus the gaze of faith on Him, and the Saviour will come to you.

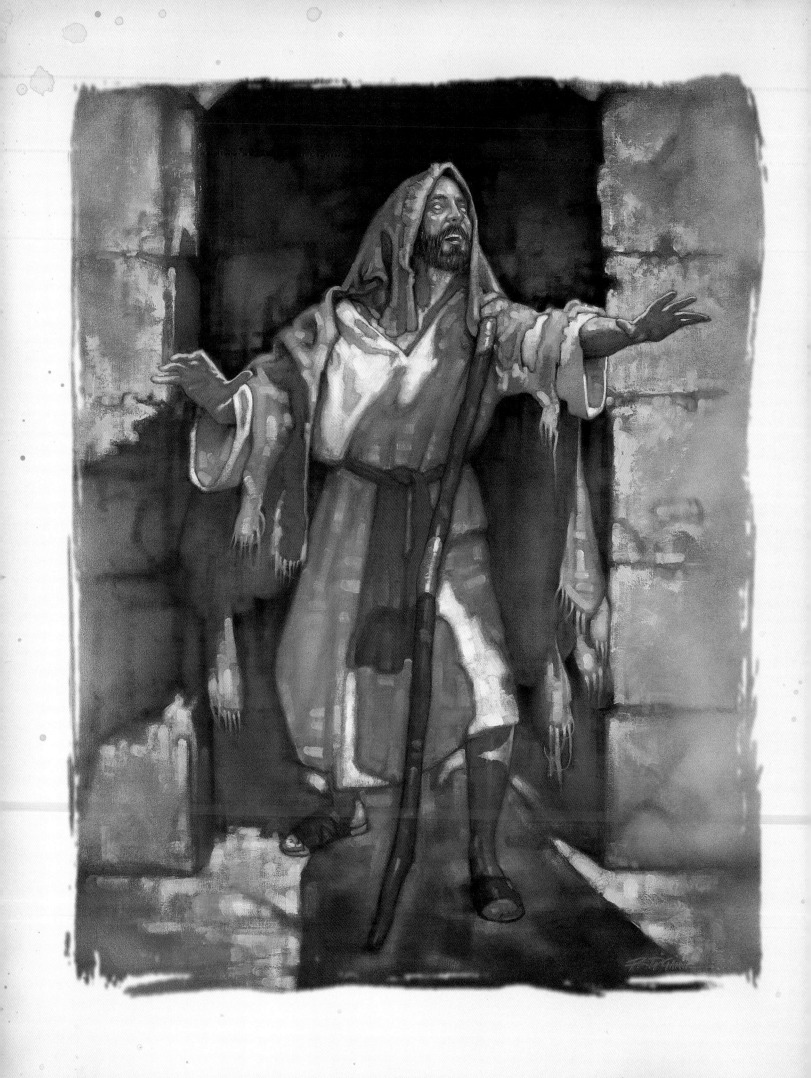

THE SAVIOUR AND THE BLIND MAN

THE DAY BEGAN LIKE ANY OTHER day for blind Bartimaeus. Waking up, he shook the straw from his shabby, torn garments, stretched, got to his feet, and began tapping his way along the familiar turns leading to the main gate in Jericho. He begged a crust of bread or two at familiar stops along the way. Arriving at the gate he took his usual place with the other beggars. He drew his ragged cloak tight around him against the morning chill. ¶ He sat there, like so many days before, listening to the city come to life. First a donkey passed by loaded with melons for market. Then several women with pitchers chatting on their way to the well. Then the clomp of camels' hooves, and the aroma of fish being carried to the market. Soon Jericho was humming, and blind Bartimaeus began intoning his beggar's cry.

But then Bartimaeus tensed and lifted his head. His blind-sensitive ears detected the hubbub of a great crowd approaching. First young boys came running with shrill cries ahead of the crowd. Then hordes of people hurried past the gate talking excitedly. Brushed by a robe, Bartimaeus reached out and grasped the hem. "What's happening?" he asked. The passerby pulled his robe back to himself and called back,

"Jesus of Nazareth—the one who heals the lame and lepers and blind—the one some are saying is the Messiah . . . He's coming, right by here!"

Jesus. Everyone had been talking about Jesus' miraculous works. Bartimaeus knew the stories well. How often he had wondered about Him. Suddenly he knew. *This must be the Messiah, and now He is coming.* His heart began to pound; his hands began to tremble. The Saviour was coming!

The excited crowd pressed closer. Shouts of "Hosanna" rang out. Bartimaeus was jostled. Jesus would soon be gone. *He had to do something.* "When he heard that it was Jesus of Nazareth," Mark tells us in his gospel, Bartimaeus "began to shout, 'Jesus, Son of David, have mercy on me!' Many rebuked him and told him to be quiet, but he shouted all the more, 'Son of David, have mercy on me!'" (10:47–48).

Afraid to get up and risk being trampled by the crowd, Bartimaeus made sure he was heard—crying pitifully, chanting at the top of his lungs, desperate, frantic. The people around him tried to silence him. "Quiet, blind man, you're making a scene!" Others chided, "Shut up, beggar!"

No way would Blind Bart shut up! The more he was rebuked, the more he cried out. The shouts rang back and forth.

"Son of David, have mercy on me."

"Quiet, beggar."

"Son of David, have mercy on me."

"Will someone shut him up?"

"Son of David, have mercy on me."

"If you don't stop, you're gonna need some mercy!"

"Son of David . . . !" He was beyond control.

What was really happening? If we pause the scene for a moment, we will see some of the most beautiful truths of Scripture.

To begin with, *Bartimaeus was profoundly aware of his condition.* He knew he was blind; he knew he was lost in perpetual darkness. From the darkness of his mother's womb he had passed into the darkness of the world. He had never seen a tree wave its arms in the spring, or the blue of a summer sky, or the face of his mother or anyone else who loved him. Unlike so many today who are lost in spiritual darkness, he knew what his problem was. Blind Bartimaeus' pitiful cry—"have mercy on me"— came from a profound self-understanding—and it brought grace.

Bartimaeus also displayed penetrating insight into who Jesus was. Over and over he cried out, "Jesus, Son of David . . . Jesus, Son of David . . ." ascribing to Jesus the messianic title of the Saviour. Though no theologian, blind Bartimaeus saw the truth

that escapes the eyes of so many. Someone once bluntly asked blind and deaf Helen Keller, "Isn't it terrible to be blind?" To which she responded, "Better to be blind and see with your heart than to have two good eyes and see nothing." So it was with Bartimaeus. Perhaps blindness has its benefits—time to think without distractions, time to reflect and see with the heart. Recognizing his own darkness and desperate need, he understood who Jesus was—none other than the Saviour promised long before.

Here was Bartimaeus' only hope. He knew his desperate condition, he knew who Jesus was, and nothing could stop him. Bartimaeus decided to "go for it!" Thus, the final, complementary truth we see is *Bartimaeus' passionate persistence.* Not even a hostile crowd could stop him. Like a little child trying to get his parents' attention, he kept shouting again and again, "Jesus, Son of David, have mercy on me!" How clearly Bartimaeus reflected the attitude of the heart we all must have if we are ever to know Jesus. "I tell you the truth," Jesus said, "anyone who will not receive the kingdom of God like a little child will never enter it" (Mark 10:15). Bartimaeus did just that. His extreme sense of urgency was a mirror of what ought to be in our own souls. Spiritual blessing belongs only to those who passionately persist. "Blessed are those," Jesus said, "who hunger and thirst for righteousness, for they will be filled" (Matthew 5:6).

Helpless, Bartimaeus "went for it"—and Jesus heard him above the crowd. Mark records, "Jesus stopped and said, 'Call him.'" We must remember that Jesus was on the way to His terrible cross. The last stop, Jerusalem, was just eighteen miles away. And yet Jesus had time for this poor beggar. The Son stood still to shine on this one man who knew he needed the Saviour.

What a window into our risen Saviour's heart. He is alive today in heaven doing the things that He did while here on earth—but in a far more exalted way. Over the tumult of the crowd He instantly hears our cries, even when millions cry to Him at the same time. Are you hurting? Do you feel helpless? If so, understand that your plea will fall with sweetness on the Saviour's ears.

The instant Bartimaeus heard the command, he stopped his cry, threw off his moth-eaten cloak, sprang to his feet, and made his way to Jesus. Can you imagine Bartimaeus' thrill? If his heart was pounding before, what was it doing now? What a painting this would make. Face to face. Jesus with the most penetrating eyes ever, and the sightless eyes of Bartimaeus fixed in an expression of ultimate expectation. This is the way to come to Jesus.

Now that the moment had come, the exchange was remarkably simple. "'What do you want me to do for you?' Jesus asked him. The blind man said, 'Rabbi, I want to

see.'" Why did Jesus make Bartimaeus express his desire? Surely to strengthen his faith. And Bartimaeus knew *exactly* what he wanted. If we knew our needs as well as he, what blessing for us would follow. "'Your faith has healed you,'" Jesus said. "Immediately he received his sight and followed Jesus along the road" (Mark 10:52).

What was it like for Bartimaeus to suddenly receive his sight? The story of Anna Mae Pennica, appearing some time ago in the *Los Angeles Times*, helps us capture something of the wonder.

Anna Mae Pennica was a sixty-two-year-old woman who had been blind from birth. At age forty-seven, she married a man she'd met in a Braille class. For the first fifteen years of their marriage, he did the seeing for both of them, until he too completely lost his vision. Mrs. Pennica had never seen the green of spring or the blue of a summer sky. Yet because she had grown up in a loving family, she never felt resentful about her handicap and always had a remarkably cheerful spirit.

Then in October 1981 Dr. Thomas Pettit of the Jules Stein Eye Institute in Los Angeles performed surgery and removed the rare congenital cataracts from the lens of Mrs. Pennica's left eye—and she saw for the first time ever.

The newspaper account tells us that she found everything "so much bigger and brighter" than she ever imagined. While she immediately recognized her husband and others she had known well, other acquaintances were taller or shorter, heavier or skinnier than she had pictured them in her mind's eye. Since that day, Mrs. Pennica can hardly wait to wake up every morning, splash her eyes with water, put on her glasses, and enjoy the changing morning light. Her vision is almost 20/30—good enough to pass a driver's test.

Think how wonderful it must have been for Anna Mae Pennica when she looked for the first time at faces she had only felt, or when she saw the kaleidoscope of a Pacific sunset, or a tree waving its branches, or a bird in flight. The gift of physical sight is wonderful. And the miracle of seeing for the first time can hardly be described.

Imagine how it was for Bartimaeus. Blind at the beginning of Christ's sentence, he was seeing before the Saviour's words were finished! No surgery. No bandages. No adjustment. Boom—sight! He saw human beings for the first time. He saw the gawking crowd. He saw the surrounding city of Jericho. He saw the hills of Moab off in the distance. But the thing he saw first was the face of Jesus. As Clarence Macartney expressed it so well:

> And for you and me, too, that will be the greatest of all sights. When we
> awake from the dream men call life, when we put off the image of the earth

20

and break the bonds of time and mortality, when the scales of time and sense have fallen from our eyes and the garment of corruption has been put off, when this mortality has put on immortality and this corruption has put on incorruption and we awaken in the everlasting morning, that will be the sight that will stir us and hold us![1]

In the final analysis, it was all because of Christ. Jesus did say, "Your faith has saved you." Christ had indeed responded to Bartimaeus' understanding of his own darkness, his perception of who Christ was, and his persistence. But it was Jesus who came to him—for blind Bartimaeus could not have searched for Christ—and it was the Saviour who called forth the man's faith. Bartimaeus was *saved* both physically and spiritually, and immediately he followed Jesus. And what an eyefull he would get in the coming days—the jubilant Triumphal Entry, the terror of the Cross, the joy of the Resurrection.

What an example Bartimaeus is for each of us. There is not one who does not need to cry out to the Saviour, "Jesus, Son of David, have mercy on me!" There is no one who does not need to come stumbling to Christ saying, "Lord, take away my darkness, my sin. Give me life!"

Jesus passed through Jericho that day never to come that way again. Bartimaeus would have no other chance. Is the Saviour speaking to you today? Will you ever have another chance?

1. Clarence Edward Macartney, *Great Interviews with Jesus* (New York: Abingdon-Cokesbury, 1944), pp. 148–150; adapted from Macartney's original words.

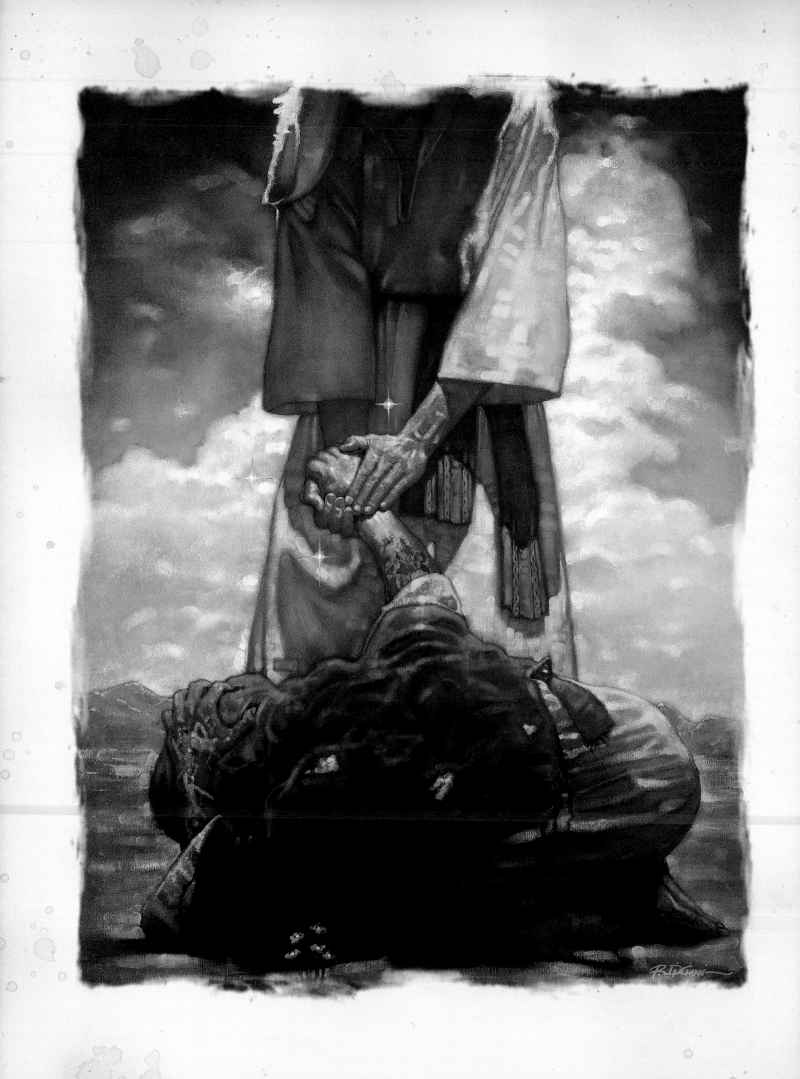

THE
SAVIOUR
AND THE
LEPER

IT BEGAN AS ONLY A SPARK OF HOPE in the heart of one who had lived without hope for so long. News of the healings had spread even to the wretched lepers' camp. But most of the lepers discounted the news as the mistaken rumors of a gullible crowd or the wishful thinking of hopeless people. ¶ But for one leper it seemed like it must be something more. There were so many healings—people in pain, people who were paralyzed, people who were demon-possessed—all healed by someone called Jesus. Could the news be wrong? Could the crowds who followed Him everywhere—from Galilee, to Jerusalem, to Judea—could they just have been swept away by some mass delusion? Or could this Jesus really be the Saviour, the promised One of long ago?

The spark flared for a moment, fanned by the breeze of hope. *If this Jesus could heal others, what about me?* the leper thought. But leprosy was different. Leprosy was the most dreaded disease of all. Every time he lifted his own nubs where fingers once had been, every time he caught the reflection of his face as he sipped water from his cup, he was reminded of just how much damage the disease had done. Would Jesus really care about one leper?

23

"And yet," he said to himself, "the prophets *did* predict . . . And the reports keep on coming . . . Yes, perhaps, if He is willing . . ."

He knew there was only one thing to do. Forgetting the stares, the disdain, the fear caused by his miserable condition, he must go to this One they called the Saviour.

We can hardly imagine the humiliation and isolation of this leper's life. In ancient Israel the dismal plight of the leper was summed up in the book of Leviticus: "The person [with leprosy] must wear torn clothes, let his hair be unkempt, cover the lower part of his face and cry out 'Unclean! Unclean!' As long as he has [leprosy] he remains unclean. He must live alone; he must live outside the camp" (13:45–46). He was ostracized from society. He had to dress in rags and cry out, "Unclean! Unclean!" whenever he came near anyone else. Think how you would feel calling out this way as you enter the grocery store or walk through a mall—the pervasive sense of worthlessness and despair.

By Jesus' time matters were even worse. It was illegal to even greet a leper. If a leper stuck his head inside a house, it was pronounced unclean. Lepers had to remain fifty yards away when they approached anyone from upwind. The eminent Jewish historian Josephus wrote in the second century that lepers were treated like "they were . . . dead men."

As if the prow of a boat were moving through the multitude, the leper steadily made his way to Jesus. People pressed back, fearing contamination. Many cursed his very presence. As the crowd scrambled to make way, his pitiful cry rose above the tumult: "Unclean! Unclean!" Finally reaching Jesus, Mark's gospel tells us that "he fell with his face to the ground and begged him, 'Lord, if you are willing, you can make me clean'" (5:12).

The poor leper had no illusion about his miserable condition. And in this we see the most important fact for everyone who would come to the Saviour—we must recognize our desperate need. He not only said he was unclean—he *knew* he was unclean. If he ever doubted, he only needed to lift his disfigured hand before his eyes and all doubt would vanish in ugly recognition. He saw himself as perfectly hopeless. There was nothing he could do. He was the perfect picture of Jesus' own words: "Blessed are the poor in spirit. . . . Blessed are those who mourn . . . " (Matthew 5:3–4).

The pitiful refrain—"Unclean! Unclean!"—had shaped the leper's soul. He was a beggar indeed. But as such he was in the perfect place to receive God's grace.

The stark truth of the leper's story is that we all are spiritual lepers. All of Christ's miracles are living parables, and throughout the Scriptures leprosy is symbolic of sin. Likewise, the healing of leprosy is especially a parable of the Saviour's deliverance

from sin. With its insidious beginnings, its slow progress, its destructive power, and the ultimate ruin it brings, leprosy is a powerful symbol for sin and moral depravity. If we see ourselves with spiritual eyes, we will recognize our own wretched condition apart from Christ.

But unlike the leper, we are often unconscious of our sin. We do not realize that sin lies at the very nature of who we are, and that there is nothing we can do to make ourselves clean. The more we think there is nothing wrong, the more advanced our leprosy is. "Hey, I'm OK!" we often say, even while the disease of leprosy pervades our souls. As Dr. Martyn Lloyd-Jones, the great preacher in London's Westminster Chapel often stressed, without a profound sense of sin,

> you are not a Christian, you do not believe in Christ as your personal Saviour. Until you realize [the gravity of your sin], you cannot possibly have felt the need of Christ. You may have felt the need of help and advice and comfort, but until you awake to the fact that your nature itself is evil—until you realize that your trouble is that you yourself are wrong, and that your whole nature is wrong . . . you will never have felt the need of a Saviour. Christ cannot help or advise or comfort you until He has first of all saved you, until He has changed your nature.
>
> Oh, my friends, have you yet felt this? God have mercy upon you if you haven't. You may have been inside the church all your life and actively engaged in its work, but still I say (and I am merely repeating what is said repeatedly in the Bible) that unless you have at some time or other felt that your very nature itself is sinful—that you are, in the words of St. Paul, "dead in sin"—then you have never known Jesus Christ as a Saviour, and if you do not know Him as a Saviour you do not know Him at all.[1]

The truth we see so clearly in the leper's story is that the Saviour doesn't come to the self-sufficient—to those who think they have no need, or who think they can make it on their own. He comes to the empty in spirit, to those who mourn their condition. How simply and perfectly Jesus said it: "Blessed are the poor in spirit, for theirs is the kingdom of heaven. Blessed are those who mourn, for they will be comforted." This is the only way that any of us can come to Christ—crying out, "Unclean! Unclean!"

Sadly, many do *not* come, for sin deceives with two exactly opposite lies. Some believe the lie that they aren't really sinners, or that they're at least "good enough." But others never come to Christ because they believe they are *too sinful* and beyond His help. As a pastor, I've talked to many who feel this way. They recite their sins

thinking I'll be shocked. The fact is, I *can't* be shocked! I've heard it all—and I can say Christ is sufficient for all! As the leper said, "Lord, if you are willing, you can make me clean." And for all who recognize their desperate need Jesus answers: "I am willing. Be clean!" This is the answer echoed throughout the pages of Scripture. Peter writes that God "is patient . . . not wanting anyone to perish" (2 Peter 3:9). Paul writes that God "wants all men to be saved" (1 Timothy 2:4). And Jesus' own words are, "Whoever comes to me I will never drive away . . . everyone who looks to the Son and believes in him shall have eternal life" (John 6:37, 40).

When we recognize our need and come to Jesus, how does He respond? Yes, He takes away our sin, He makes us clean, He saves us for all eternity. But there is even more here. As the leper lay at Jesus' feet, Jesus looked on him as he had never been looked at before. Mark (1:41) says Jesus was "filled with compassion"—deeply moved by the leper's condition and his recognition of his desperate need.

What a revelation of the Saviour's heart we see here! Take this to your own heart, and hold it there with all you have. The Saviour has compassion for the leprosy of your heart. But He does more than just understand. He *felt* the crushing weight of your sins and mine as He bore them on the Cross. Take heart! There is Someone who feels with you, who knows the hurt and sorrow and pain of sin in your life. And in His infinite love for us, He takes it all upon Himself.

And then Mark says, "Jesus reached out his hand and touched the man." Do you understand the significance of that touch? Perhaps it had been twenty or thirty years since that leper had been touched. Perhaps he was a father and had once known the embrace of his children and his wife. But for years he had not known even a touch. How he must have longed for a caress. I once counseled a lonely man. He had no family that cared. He belonged to no church. In describing his loneliness, he said that he had his hair cut once a week, just to have someone touch him without misunderstanding. Imagine the leper's longing for a touch or a caress.

Time stood still as Christ touched him. It was more than a casual contact. Quite literally, Jesus "took hold" of the leper. We cannot begin to describe the ecstasy that coursed through that leper's body. The onlookers were shocked. The disciples were appalled. By law, Jesus was now unclean Himself—and even (they thought) contaminated by the dreaded disease!

Why did Jesus do this? In one sense it was most natural for Him to do it. But more than this, He wanted the leper to *feel* His compassion. The Saviour's touch said, "I'm with you. I understand. I love you." But there is also a much deeper reason: the touch of the Saviour's pure hand on the rotting, leprous flesh is a parable of

the Incarnation and of the Cross. For in the Incarnation Christ took on human flesh Himself. And in taking on our sin, He gave us His own purity. "God made him who had no sin to be sin for us, so that in him we might become the righteousness of God" (2 Corinthians 5:21). What a wonder this is. Jesus laid hold of our flesh. He touched us and healed us.

Can you imagine the crowd's amazement? "Immediately the leprosy left him." The healing was *sudden* and *complete*. The man's toeless feet were suddenly whole. The knobs of his hands grew fingers before his very eyes. Ears, nose, skin were as soft and supple as a little child's. Can you hear the roar of the multitude? Can you hear the man's ecstatic cry—no longer "Unclean! Unclean!" but *"I'm clean! I'm clean!"*

May we not miss what this means for you and for me. This is what the Saviour can do for you—in an instant, in a split second of belief. When we fall on our knees before Him, He reaches out and touches us. He heals the leprosy of our soul.

Do you know the Saviour? Won't you fall before Him? Won't you tell Him of your desperate need? Then feel His touch and hear His word to you—"I am willing . . . be clean."

1. From Ian H. Murray, *David Martyn Lloyd-Jones, The First Forty Years, 1899-1939* (Edinburgh: Banner of Truth, 1982), p. 207; edited slightly from the original text to simplify punctuation.

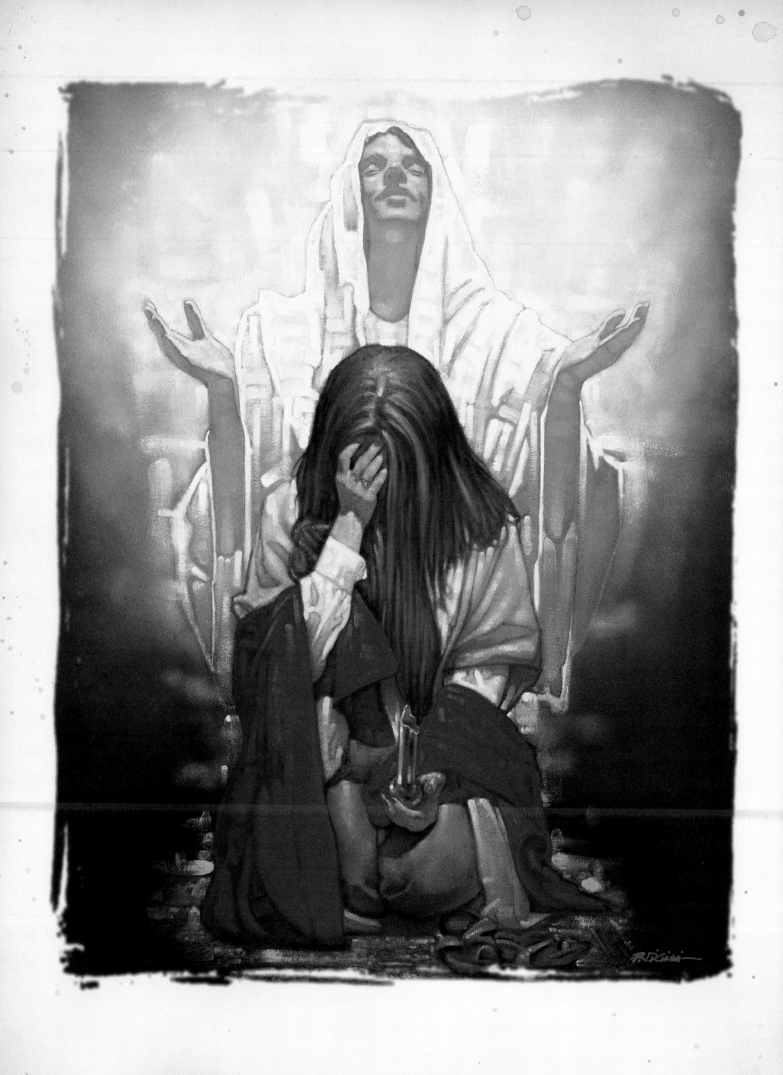

THE
SAVIOUR
AND THE
SINNER

THE GUEST LIST HAD BEEN PRE-pared with great care. All the important men of the synagogue were coming. And Simon, himself a leading Pharisee, spared no expense to impress his dinner guests. Even Jesus would be there. It was the talk of the town. "Quite a party Simon's planned. Can you believe the people he's invited? Let's drop by and see if we can get a look inside." ¶ The time arrived, and the guests came in ones and twos. Simon greeted each warmly as was the custom—hands on their shoulders and a kiss of peace on their cheek. As they took their places, Simon's servants rushed to remove their sandals and bathe their dusty feet in cool basins of water. Relaxed and refreshed, the guests reclined around the sumptuous table, exchanging pleasantries of the day.

The scene was the epitome of prosperous Jewish culture. There was Simon's well-appointed home with servants bustling in attendance. There was the central courtyard, its table spread with the best produce of the region. There were the well-upholstered couches surrounding the dinner table, where guests would recline in the traditional way—leaning on the left elbow, eating with the right hand, their feet extending behind them.

As always, the doors of the home were kept open for the uninvited townspeople to wander freely and observe the luxurious display. What an opportunity for the common folk to catch a glimpse of the rich and famous. And what an opportunity for the upper crust to flaunt their importance.

But something was amiss. For one guest there had been no warm greeting, no kiss of peace. No servants hurried to bathe His dusty feet. Like the other guests, Jesus reclined at the table—His grimy feet an undeniable sign of his host's contempt. Simon had made his point.

But the day was not to go quite as Simon had planned so carefully. For something happened to shock the genteel sensibilities of the distinguished guests. As Luke explains:

> When a woman who had lived a sinful life in that town learned that Jesus was eating at the Pharisee's house, she brought an alabaster jar of perfume, and as she stood behind him at his feet weeping, she began to wet his feet with her tears. Then she wiped them with her hair, kissed them and poured perfume on them.
>
> (Luke 7:37–38)

Expressions of shock swept through the guests. The woman was a notorious sinner, a prostitute, a woman of the street! Her defiling hands were touching Jesus!

As the notorious woman bent over the Saviour's feet, the murmurs gave way to an embarrassing silence. She was in an obvious state of emotional agitation. Just to be in the Pharisee's house was a grave breach of social decorum. She could not control her trembling. Her damp, quivering hands clasped a small, thin-necked alabaster vial of concentrated perfume poised to anoint Jesus' feet.

Why was she there? It must have been out of a deep sense of gratitude. Somewhere, somehow—in a public sermon? in a private conversation?—Jesus' words had reached her heart. She had found forgiveness. And now she felt compelled to do something. Her newfound joy combined in that moment with the sorrow of seeing Jesus so disgracefully treated—and thrust her forward to do Him honor.

There she was at the Saviour's feet, perfume in hand, about to pour the soothing oil. But everything went wrong! Her tears began to fall like raindrops in the dust, spattering and streaking His soiled feet. She hadn't meant for it to happen this way! And she had no towel. She did the only thing she could. Unloosening her waist-length hair she let it fall from her head and began to wipe clean the Saviour's feet.

A second wave of shock swept through the guests. This was something never to be done. A woman was permitted to loosen her hair only in the presence of her hus-

AND THE SINNER

band. Under Jewish law, a woman could be divorced for such a scandalous act. It was tantamount to uncovering herself in public.

By now there was no place to hide. Deliberately she broke the fragile stem of the costly vial and poured the contents on His feet. As the aroma filled the air, she covered His feet with her kisses.

It is a passionate picture. It is even embarrassing. I would be embarrassed if I saw such a display. Yet while it is passionate, it is not unseemly. It is the passionate outpouring of love by a redeemed soul. It is an act of desperately joyous humility. She loved Jesus. And she was in the spring of spiritual health. C. S. Lewis once wrote to a little girl, "If you continue to love Jesus, nothing much can go wrong with you, and I hope you may always do so." Here was a big girl, with far more experience in life—most of which she would rather forget. But she loved Jesus! And despite her sad past, she was brimming with spiritual life.

The people were so astonished, not a word had been spoken. But Simon was thinking, and Jesus knew his contemptuous drift. "If this man were a prophet," Simon thought, "he would know who is touching him and what kind of woman she is—that she is a sinner" (verse 39). Simon's righteousness was of the kind that would want Jesus to kick the repentant woman back to her sin and misery. What an indictment. Simon the moralist had an arctic heart, a permafrost of the soul. His was a heart without grace.

In reality Jesus knew exactly what was going on in Simon's heart, and He sought to reveal the truth to him by telling a parable.

> Jesus answered him, "Simon, I have something to tell you." "Tell me, teacher," he said. "Two men owed money to a certain moneylender. One owed him five hundred denarii, and the other fifty. Neither of them had the money to pay him back, so he canceled the debts of both. Now which of them will love him more?"
>
> (Verses 40–42)

The point is clear. Yes, the woman in her tragic life of sin may have been ten times the sinner Simon was. But the fact is that *both* the woman *and* Simon were sinners, and *both* were utterly bankrupt. The "high-class" moralist had the same problem as the "low-class" prostitute. Neither one could pay the debt for his or her spiritual rebellion. When it comes to sin, the entire human race is bankrupt. "For all have sinned and fall short of the glory of God" (Romans 3:23). We are all debtors. We're all broke. The woman realized she could never pay. So Jesus paid it all.

This is what the Cross is all about. None of us can ever achieve the holy perfection

31

necessary to stand before God. Sin infects every area of our lives, no matter how "good" we are. Our only hope is the Cross—where the Saviour took all our sin and imperfection on Himself and paid our debt in order to give us life.

Remarkably, the drama now had shifted. Simon found himself the center of attention as Jesus asked, "Now which of them will love him more?" There was no way to escape the revealing conclusion. "I suppose," Simon grudgingly answered, "the one who had the bigger debt canceled." Yes indeed; those who have been forgiven most love the most! The miracle of grace is that among the greatest saints are some of the greatest sinners. Consider St. Augustine. As a young man he lived a life of flagrant debauchery. But through the prayers of his mother, he was convicted of sin and was converted to Christ and went on to become the greatest theologian of the early church. Or consider John Newton, who as a young man trafficked in the sale of slaves. Convicted of his terrible sin against God and man, he went on to write the beloved hymn "Amazing Grace" as a testimony of his own extraordinary conversion.

Why are there so many Christians who show so little love for Christ? Because they have never really seen what great sinners they are, and so they have never seen how sure and sweet and complete Christ's forgiveness is. Though believers, such people treat the Lord very much the way Simon did.

> Then [Jesus] turned toward the woman and said to Simon, "Do you see this woman? I came into your house. You did not give me any water for my feet, but she wet my feet with her tears and wiped them with her hair. You did not give me a kiss, but this woman, from the time I entered, has not stopped kissing my feet. You did not put oil on my head, but she has poured perfume on my feet."
>
> (Verses 44-46)

We are all in danger of being like Simon. What we need is a fresh vision of the sin that lies within us. We need to know what we really are. Nowhere is the vastness of our need more plainly stated than when the Apostle Paul wrote to the Ephesians:

> As for you, you were dead in your transgressions and sins, in which you used to live when you followed the ways of this world and of the ruler of the kingdom of the air, the spirit who is now at work in those who are disobedient. All of us also lived among them at one time, gratifying the

32

cravings of our sinful nature and following its desires and thoughts. Like the rest, we were by nature objects of wrath.

(Ephesians 2:1–3)

Everyone apart from Christ (the best and worst of us) is "dead in . . . transgressions and sins." Both the "good" and the "bad," in their spiritual deadness, are captive to the world, the flesh, and the devil; all are the objects of God's wrath.

And we who know the Saviour—we too need to be reminded often of the sin still living in us, and of the need for grace each new day. We should be like St. Paul: "Here is a trustworthy saying that deserves full acceptance: Christ Jesus came into the world to save sinners—of whom I am the worst" (1 Timothy 1:15). It is good to be like St. Francis: "There is nowhere a more wretched and miserable sinner than I." St. Paul the "worst" of sinners? St. Francis the most "wretched and miserable" of sinners? Yes, it's true! This is not hypocritical humility. The more these men walked with Christ, the more sensitive they became to the subtle presence of inner sin. Their greatness, their spiritual health, rested on their awareness of sin and the constant need of God's grace. And if it is true of the greatest saints, how much more for ordinary sinners like ourselves!

Return once more with me to the scene in Simon's home. Jesus turns toward the woman and says to Simon, "'I tell you, her many sins have been forgiven—for she loved much. But he who has been forgiven little loves little.' Then Jesus said to her, 'Your sins are forgiven.'" Can you imagine the magnitude of that moment? The woman is still kneeling at Jesus' feet. The tears still stain her face. But she is radiant. She is forgiven! She loves as she has never loved before.

What a contrast Simon makes. His jaw is set; his eyes are fixed in anger. He has no love for Jesus. He couldn't care less for the woman. He stands alone, beyond God's grace.

How beautiful the Saviour is. He is pure, utterly sinless, perfect, holy. He forgives. He accepts. And He frees us to pour out our love on Him.

And how beautiful the woman is. She has been forgiven. Though her sins were as scarlet, she is as pure as snow (Isaiah 1:18). And she *feels* it! If you understand the Gospel, you understand what has happened inside her. Oh, does she love!

How is your soul today? Do you truly love Him? Do you see your need? Do you realize you can't make it? Then the Saviour's words are for you:

Come to me, all you who are weary and burdened, and I will give you rest. Take my yoke upon you and learn from me, for I am gentle and humble in heart, and you will find rest for your souls.

(Matthew 11:28–29)

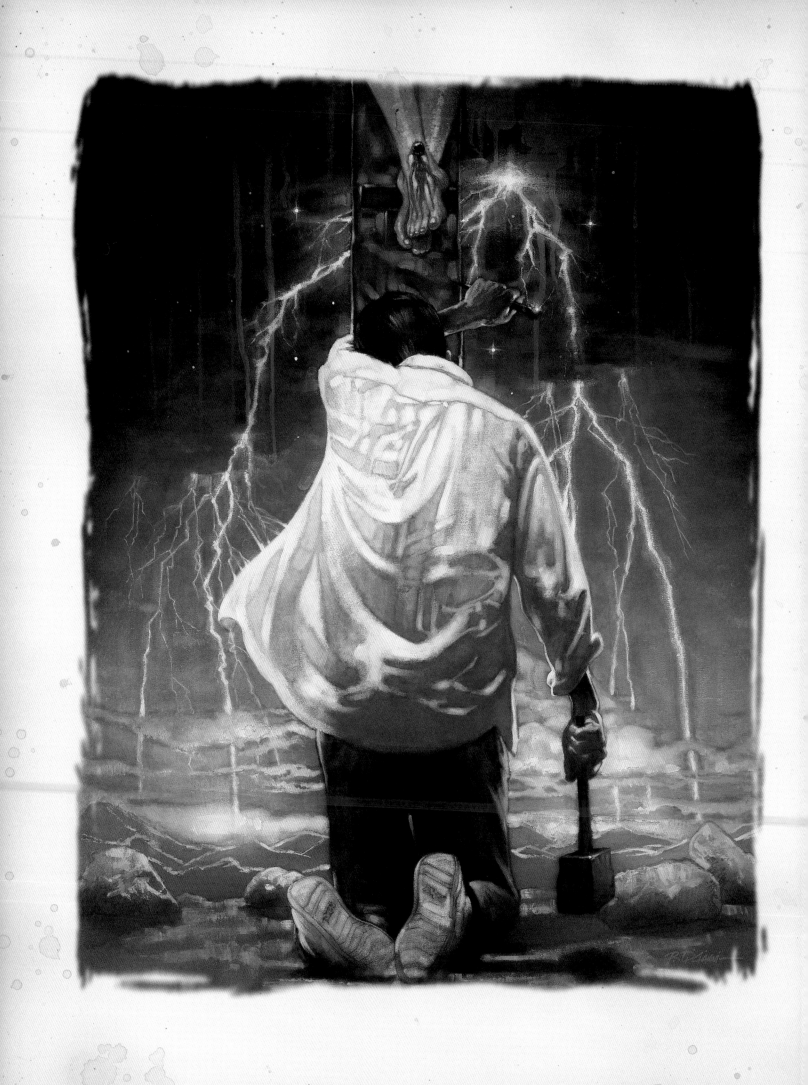

THE
SAVIOUR
AND THE
CROSS

IT WAS NO ORDINARY DARKNESS. ONE moment the noonday sun illumined the Holy City and the surrounding countryside in anticipation of the coming Passover Feast. In the next moment darkness came without warning—descending like a shroud in eerie, midday gloom.

In this preternatural night there was silence all around, in vivid contrast to the events of thirty-three years before. For at the Saviour's birth, light and song had pierced the midnight sky. Now darkness and silence descended upon the noontide scene as the Saviour died.

At first we may welcome the darkness, because it is not easy to look upon the agony of the Cross. But if we are unwilling to look, we will never understand the Cross's meaning and the terrible price the Saviour paid to redeem us from our sins.

The Cross reveals the love of God as nothing else in the universe could. We must passionately weave this truth into the fibers of our being for our own soul's health. C. S. Lewis understood this well when he wrote that "God created the universe, already foreseeing . . . the buzzing cloud of flies about the cross, the flayed back pressed against the uneven stake, the nails driven through the medial nerves, the repeated incip-

ient suffocation as the body droops, the repeated torture of back and arms as it is time after time, for breath's sake hitched up." Though God knew before the beginning of time the unfathomable cost of redemption, He created man nonetheless, as Lewis continues, "that we may exploit and 'take advantage of' Him. Herein is love. This is the diagram of Love Himself, the inventor of all loves." [1]

Yes—the Cross of Christ is the divinely given diagram of God's love! We must therefore allow its raw horror to assault us. Its blood, its water, its glistening bone ought to go to our hearts. And our hearts ought to respond repeatedly, "This is how I am loved!" There is no room for disinterested reflection. For the health of our souls, the Cross must be an object of our *passionate* attention. And so we see that the Saviour's death is dramatically emphasized by the darkness that engulfed the Cross and the unfathomable depths to which He went to bear our sins.

Why this darkness? The answer is revealed throughout the pages of God's Word. To begin with, the darkness signified the curse of God. At the Exodus, a plague of darkness spread over the land before the first Passover lamb was slain. Now before the death of the ultimate Passover Lamb, there was again darkness. God's judgment was being poured out in a midday night.

This takes us to the very center of what was happening, for in those three dark hours sin was poured upon the Saviour's soul until He Himself became sin. As Isaiah prophesied long before:

> He was despised and rejected by men, a man of sorrows, and familiar
> with suffering. Like one from whom men hide their faces He was despised,
> and we esteemed him not. Surely he took up our infirmities and carried our
> sorrows, yet we considered him stricken by God, smitten by him, and
> afflicted. But he was pierced for our transgressions, he was cursed for our
> iniquities; the punishment that brought us peace was upon him, and by his
> wounds we are healed. We all, like sheep, have gone astray, each of us has
> turned to his own way; and the Lord has laid on him the iniquity of us all.
>
> (53:3-6)

In the New Testament Peter further explains what happened: "He himself bore our sins in his body on the tree, so that we might die to sins and live for righteousness; by his wounds you have been healed" (1 Peter 2:24).

In a similar way Paul says: "God made him who had no sin to be sin for us, so that in him we might become the righteousness of God" (2 Corinthians 5:21). Or as

The Living Bible so meaningfully puts it, "For God took the sinless Christ and poured into him our sins. Then, in exchange, he poured God's goodness into us!"

Wave after wave of our sin was poured over Christ's sinless soul. Again and again during those three hours His soul recoiled and convulsed as all our lies, all our murders, all our adulteries, and the noxious brew of our hatreds, jealousies, and pride were poured on His purity. Finally He Himself became a curse: "Christ redeemed us from the curse of the law by becoming a curse for us, for it is written: 'Cursed is everyone who is hung on a tree'" (Galatians 3:13).

In the darkness Jesus bore it all in silence. No bitter words came from his lips. Can you see Him writhing like a serpent in the gloom (see John 3:14-15)?

But there is even more! Because He became sin for us, He had to undergo the cosmic trauma of separation from God the Father, in whom "there is no darkness at all" (1 John 1:5). In the dark, dark night of the Cross, Jesus was alone. His separation was not just felt—it was real. The separation of the Son from the Father and from the Spirit was fact. As the Son became sin, God's holy nature demanded separation. Not even the most evil man (including Nero or Hitler) has *in this life* ever known the horror of being completely cut off from God. But the Saviour knew it. There on the Cross He was experiencing what He had seen so clearly in the Garden of Gethsemane, the anticipation of which almost brought Him to death. Though His physical agony is beyond our comprehension, it was nothing compared to the agony caused by the crushing weight of sin—my sin and yours.

Under the supernatural shroud of darkness, the silence went on for one hour, for two, for three. At the end of the third hour, the silence was shattered as "Jesus cried out in a loud voice, *'Eloi, Eloi, lama sabachthani?'*—which means, 'My God, my God, why have you forsaken me?'" (Mark 15:34). Hearing Jesus apply the prophetic words of Psalm 22 to Himself, the onlookers reeled in shock. As John Calvin understood so clearly, "Jesus expressed this horror of great darkness, this God-forsakenness, by quoting the only verse of Scripture which actually described it." In perfect fulfillment of the prophetic Psalm, Jesus both laid bare His soul and proclaimed His trust in His Father. And with this ringing declaration of abandonment, He drained the cup to the dregs, and the darkness began to lift.

Jesus was fully conscious as the end drew near. As an eyewitness to the scene, the Apostle John records: "Knowing that all was now completed, and so that the Scripture would be fulfilled, Jesus said, 'I am thirsty'" (John 19:28). Under the murky sky, a soldier "filled a sponge with wine vinegar, put it on a stick, and offered it to Jesus to drink" (Mark 15:36). Having tasted this last bitter drink, Jesus lifted Himself back

up and pierced the gloom with the decisive cry, "It is finished!" (John 19:30) and then uttered His final words, "'Father, into your hands I commit my spirit.' When he had said this, he breathed his last" (Luke 23:46).

"It is finished!" Do you see the significance of Jesus' cry? Not that *He* was finished by His enemies. Not even that Jesus' suffering was now over. But that the work of salvation was forever completed. The literal meaning of the text is: "It has been and it forever will be finished!" As the sun burst through to conquer the shroud of darkness, the greatest work ever performed was *finished.* Jesus had gone lower than any human had ever gone as your sins and mine poured over His wincing body. He suffered a greater isolation from the Father than any living soul had ever undergone. And He conquered! Thus He could shout in victory, "Finished!" and confidently yield His spirit to the Father.

What will be our response? First and foremost, we must recognize that the Saviour has done everything Himself *for us,* for our salvation. There is nothing we can do, nothing we can add. If any of us would have the audacity to suppose that we can add to His saving work, we heap on Him a terrible insult! Salvation comes by trusting in the Saviour's finished work—and nothing else. Are you trusting in Him alone? If so, hold these words in your heart:

> When I survey the wondrous cross,
> On which the Prince of Glory died,
> My richest gain I count but loss,
> And pour contempt on all my pride.
>
> Forbid it, Lord, that I should boast,
> Save in the death of Christ, my God;
> All the vain things that charm me most,
> I sacrifice them to His blood.[2]

When we stand before the Cross and truly see the Saviour for who He is and truly see ourselves for who we are, there is only one response we can honestly make. Thus Mark concludes his account with the response of the Roman soldier who oversaw the crucifixion: "And when the centurion, who stood there in front of Jesus, heard his cry and saw how he died, he said, 'Surely this man was the Son of God!'" (Mark 15:39). We do not know if the centurion's response was a momentary recognition of Christ's deity or a lasting commitment to Christ as Lord and Saviour. But we do see

that when Jesus' death is carefully considered, we will recognize the Saviour for who He was and is.

But we who know the Lord should see so much more than the soldier, for we see the depths Jesus went to in order to redeem us. We see Him writhing under our own sins as they are poured onto Him. We see Him become a curse for us, that we might become righteous. We see him utterly alone, separated from the Father in darkness and silence. And we say with the deepest passion, "Surely this man was the Son of God!"

Jesus told of His coming death on the Cross by saying, "When I am lifted up from the earth, [I] will draw all men to myself" (John 12:32). As those who love the Saviour, we confess that we are drawn to the Cross. The Cross—with its bone and blood and sweat—is everything. There is no darkness over the heads of those who trust in Christ. The sun shines with the greatest intensity. In the darkness our sins were poured on the Saviour, so that He became sin for us. In the darkness He bore the penalty for our sins. In the darkness He endured the wrath of God in our stead. His great shout—"It is finished!"—meant that He had done everything for us and for our salvation. He had defeated the darkness forever. We can add nothing; indeed we must add nothing. "Herein is love. The diagram of Love Himself, the inventor of all loves."

> Love so amazing, so divine,
> Demands my soul, my life, my all.[3]

1. C. S. Lewis, *The Four Loves* (New York: Harcourt, Brace, Jovanovich, Inc., 1960), p. 176.
2. From Isaac Watts, "When I Survey the Wondrous Cross," 1707.
3. Ibid.

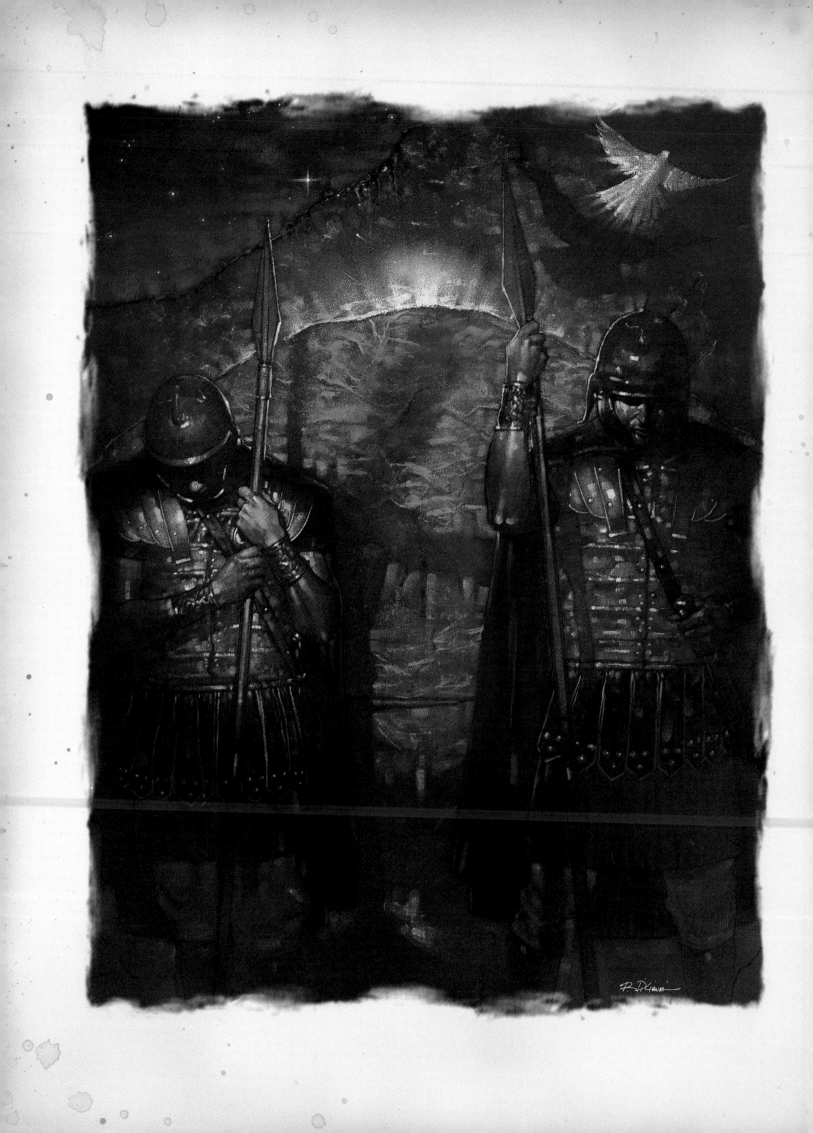

THE SAVIOUR AND THE EMPTY TOMB

THE DARKNESS HAD BEEN DEFEATED forever, but the light had not yet dawned in the hearts of Jesus' disciples and loved ones who stood near the Cross. The night before the Resurrection was indeed the darkest hour for those who loved the Lord. There was Peter's paralyzing guilt, beloved John's heartache, Mary Magdalene's desperate longing. That Saturday before Resurrection Morning was a day of desolation, shattered dreams, and darkness. ¶ Was there nothing they could do? A band of devoted women roused early, if indeed they slept at all. They could at least go to Jesus' tomb to demonstrate their devotion for the One they loved. As they left their homes in the pre-dawn darkness, a chill still hung in the air awaiting the rising sun. The path was yet wet with dew as they rendezvoused along the way.

There were at least four women, and probably more—including Mary Magdalene (from whom seven devils had been cast out) and Mary the mother of James. Also Salome and Joanna and others who had been close to Jesus.

What did they expect to find? The risen Saviour? We see that they did not have the slightest idea of resurrection in their minds. "Who will roll the stone away from

41

the entrance of the tomb?" they fretted together (Mark 16:3). Why had they not thought of it? It would take much greater strength than they had to move the stone. No, they did not come in faith believing. They expected only to find the lifeless frame of the One they loved. They came with a mission to perform—to wash and perfume His familiar face, and to wrap spices in the linen strips of swaddling cloth. Their action would be of no use to their dead Master, but it was what their hearts needed.

But what they found rocked them to the core. The stone was moved—rolled back from the entrance, leaving a terrifying, black, gaping maw. They fell back in confusion. What had happened? Had someone broken into the tomb? Where were the soldiers? As Matthew's gospel dramatically describes the scene:

> There was a violent earthquake, for an angel of the Lord came down from heaven and, going to the tomb, rolled back the stone and sat on it. His appearance was like lightning, and his clothes were white as snow. The guards were so afraid of him that they shook and became like dead men.
> The angel said to the women, "Do not be afraid, for I know that you are looking for Jesus, who was crucified. He is not here; he has risen, just as he said. Come and see the place where he lay. Then go quickly and tell his disciples."
>
> (28:2–7a)

There was only one thing to do—inform the disciples! And Mary Magdalene took off, her robes trailing in her breathless wake. As the apostle John continues,

> [Mary went] running to Simon Peter and the other disciple, the one Jesus loved [the Apostle John], and said, "They have taken the Lord out of the tomb, and we don't know where they have put him!" So Peter and the other disciple started for the tomb. Both were running, but the other disciple [John] outran Peter and reached the tomb first. [John] bent over and looked in at the strips of linen lying there but did not go in. Then Simon Peter, who was behind him, arrived and went into the tomb. [Peter] saw the strips of linen lying there, as well as the burial cloth that had been around Jesus' head. The cloth was folded up by itself, separate from the linen. Finally the other disciple [John], who had reached the tomb first, also went inside. He saw and believed.
>
> (20:2–8)

Each of these three—Peter, John, and Mary Magdalene—responded differently to the empty tomb, and each reveals much about our own response to the Saviour. Of

42

John the Scriptures say simply that "he saw and believed." What did John believe— that Jesus was gone? No, he already knew that. What John saw made him believe in the Resurrection—the *first* to believe.

If we look carefully at the text we see that John outran Peter and took a quick look into the tomb, but did not go in. Peter then came along immediately. Huffing and puffing, he brushed John aside and barged into the tomb. Peter took a long, careful look at "the strips of linen lying there, as well as the burial cloth that had been around Jesus' head . . . folded up by itself, separate from the linen." Remarkably, Luke's gospel tells us that although Peter saw all of this he "went away, wondering to himself what had happened" (Luke 24:12).

How different their responses were. Both Peter and John saw the same grave wrappings lying like a collapsed cocoon. They saw the unmoved face cloth remaining exactly in place. They saw that Jesus' body had disappeared—passed through the cloths, leaving them lying limp and undisturbed. John saw the whole thing and reached the only possible conclusion. We can hear John in his excitement trying to convince Peter: "Peter, don't you see it? No one has done anything with the body. It's gone right through the cloths! Jesus is risen! He's alive! The only possible answer is resurrection." And that is as true today as it was 2,000 years ago. There is no other possible explanation. Jesus is risen! Oh, that we would look at the evidence and reach the same conclusion.

We do not know why Peter did not immediately believe. Was it the guilt he felt for denying Christ? Was it just that he needed more time to let the stunning events sink in? In any case Peter soon came to see and understand as John did—with a passionate faith in Christ as his Saviour. Remember also Jesus' later gentle care for Peter in restoring him to fellowship and leadership (John 21:15–17), thus confirming that Peter's faith was real too. In the end there was only one reason that John and Peter believed—because what they saw and understood was true.

But what of poor Mary Magdalene? She had already run to find the disciples and could hardly keep up with Peter and John. Now in their excitement they overlooked her, and we find Mary standing alone outside the tomb, weeping her heart out.

It was from Mary that Jesus had cast the seven devils. She had sinned much and had been forgiven much, and now she loved much! Her heart was broken. All the horror of His death, and now this last indignity. Someone had taken His mutilated body, and now they were going to make further sport of Him. How could they do such a thing? Mary was totally unprepared for the cosmic jolt of the next few seconds. Read with me John's poignant words:

But Mary stood outside the tomb crying. As she wept, she bent over to look into the tomb and saw two angels in white, seated where Jesus' body had been, one at the head and the other at the foot. They asked her, "Woman, why are you crying?" "They have taken my Lord away," she said, "and I don't know where they have put him."

At this, she turned around and saw Jesus standing there, but she did not realize that it was Jesus. "Woman," he said, "why are you crying? Who is it you are looking for?" Thinking he was the gardener, she said, "Sir, if you have carried him away, tell where you have put him, and I will get him."

Jesus said to her, "Mary." She turned toward him and cried out in Aramaic, "Rabboni!" (which means Teacher). Jesus said, "Do not hold on to me, for I have not yet returned to the Father. Go instead to my brothers and tell them, 'I am returning to my Father and your Father, to my God and your God.'"

(20:11-17)

As Mary cried, "Rabboni" she threw her arms around Jesus in spontaneous response. But Jesus cautioned her. He wanted her to realize that a monumental change was taking place. A new relationship was in the process of being established. The comfort Mary sought in Jesus' arms was being replaced by something far greater than His physical presence could ever give. Jesus must first return to the Father. From there He would appear again to His followers and comfort them for forty days before ascending into heaven. But even this would be surpassed by the comfort of the Holy Spirit living in the believer, and even more by the final comfort of Christ's return in power and glory to take His own to reign with Him in the joy of His presence forevermore.

Poor Mary Magdalene? In reality Mary was afforded the highest honor, for it was to the *woman* Mary that Christ first appeared. Not to an apostle. Not to someone great. But to a woman—and furthermore, to one who was greatly oppressed within the culture of her time, to one who had known great sin. Mary was the first to see Jesus—which should be a great comfort to us. The Saviour does not come to the self-sufficient, but to those who know their need, to those who know how sinful they are. Let us remember well that it is only such who find resurrection life! And it will always be so.

How Mary must have felt when the Saviour spoke her name. She had been on an emotional roller coaster, and now she was deliriously on top. What joy, what peace swept over her. What news to share! John's gospel tells us that "Mary Magdalene went

44

to the disciples with the news: 'I have seen the Lord!'" (John 20:18). What delight she had in retelling the story again and again.

What do Peter, John, and Mary Magdalene have in common? They came to see that Christ is risen. They understood that the Saviour lives. And their lives were transformed for all eternity through faith in the risen Lord. They found the single, most important thing in life.

Have you seen the Saviour with the eyes of faith? Have you received your sight from Him? Have you felt His cleansing touch? Have you known His forgiving words? If you cannot answer yes, then look once more with the eyes of faith. See Him nailed to the Cross, dying for you and for me. See Him break the power of sin and death. See Him rise victorious from the empty tomb. Look in hope to His return in power and great glory.

How beautiful it is to know the Saviour—the One who calms the storms of life, who opens our eyes to eternity, who meets our deepest needs, who washes away our sin.

Do you long to know the Saviour? Then receive Him, and rejoice in knowing Him. And to you the Saviour says, in the words of a timeless hymn:

> I am your forgiveness,
>> I am the passover of your salvation,
> I am the lamb which was sacrificed for you,
>> I am your ransom,
> I am your light,
>> I am your Saviour,
> I am your resurrection,
>> I am your king,
> I am leading you up to the heights of heaven,
>> I will show you the eternal Father,
> I will raise you up by my right hand.

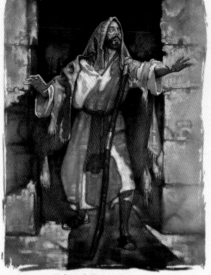

Blind Bartimaeus

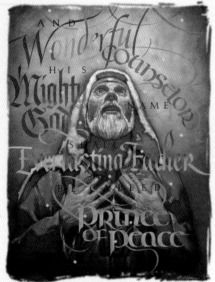

The Promise

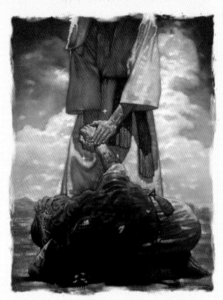

The Leper

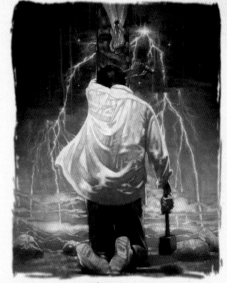

The Cross

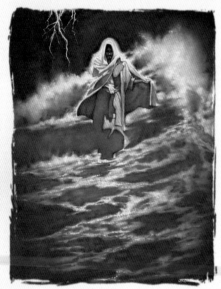

The Storm

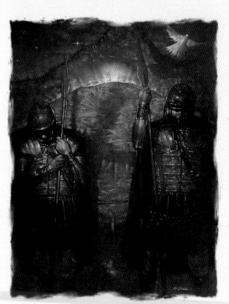

Resurrection Morning

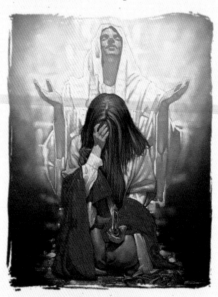

The Sinner

ARTIST'S INSIGHTS

The Promise

I read once that "prophets and trees have something in common: they are both planted for the future." While Isaiah had much to say to the people of his own time, he was privileged to deliver the ultimate promise to the world. He spoke of a special Son, Jesus Christ. The words he used still describe Him today and should be shouted from the housetops.

This painting reflects a first, as far as I know. The combination of Tim Botts's calligraphy with my painting on the same surface breaks new ground. I painted Isaiah in muted tones—and Tim used vibrant colors—to illustrate that while Isaiah was important, the message was even more important. Isaiah knew that, and I venture to say that he would have approved.

The Storm

Throughout the ages, whenever people have wanted to contrast humanity with divinity, they've said, "What, do you think I can walk on water?" There is only One who ever could. And did. See for yourself in Mark 6:45-51.

This painting is a very literal interpretation of what that scene could have looked like.

I tried to show Christ mildly affected by the wind, but certainly in total control. Waves are mounting, lightning is flashing, and somewhere, out of view, terrified disciples believe they are seeing a ghost!

However, I derive security from this passage. Once again Jesus demonstrated His sovereignty over nature. There is no hint that this miracle was even remotely difficult for Him. Metaphorically, it says that no storm—not even the one you may be enduring right now—is beyond His ability to walk through or is too great for His deliverance.

Blind Bartimaeus

"Pass me not, O gentle Savior, hear my humble cry . . ." Those familiar lyrics echo the heart-cry of the blind man who would not be denied. This was to be his moment with the Saviour.

This scene is overwhelmingly symbolic because to me the story of Bartimaeus is as much about spiritual blindness as about the physical healing of a blind man. Christ came to open blind eyes. *Spiritually* blind eyes!

This is the essence of what I tried to capture in the painting. Bartimaeus is in desperate

need—as we see from his sightless eyes, his tattered clothes, his poverty-stricken condition. But as the shadow of the Saviour falls upon him, he cannot contain his excitement. He leaves his staff behind, no longer needing it to help him find his way. He steps out of darkness into eternal light—and receives not just the physical sight he'd waited for since birth, but something more. His joy can be seen in everyone whose spiritual eyes are opened by the Saviour.

The Leper

This is for anyone who ever needed the Saviour's healing touch.

I am struck by the leper's response when He met Jesus. He lay prone. Didn't even look up. He knew Christ was his only hope, so he "implored" Jesus to heal him (NASB). Translated, that means he asked as an inferior to a superior. The result? The only One who can restore said, "I am willing." What incredible power must have been unleashed at that moment!

I purposely avoided showing Christ's face in the painting because I wanted to convey His Spirit, rather than just the historical perspective of Him. The

stars appearing at Christ's touch signal the moment of healing, as does the change in color that's starting in the leper's hand. The clouds are beginning to form a cross—a reminder of the price of this leper's healing. And the small spray of flowers poking out of the hard ground is symbolic of the new life emerging from the man's diseased body.

The Sinner

It was hard for the people who knew this woman not to judge her. But there was more to her than what they could see. When they looked at her, they saw a sinner. But Jesus saw a loving, reverent soul in need of forgiveness. This painting is my attempt to illustrate how Jesus viewed her.

The red cloak identifies her as the sinner she was. Yet she put the "holy" party-goers to shame. While they ignored Jesus, she offered Him all she had—her tears, her hair, perfume. The result? She became immortalized as the standard of love for Christ.

The timelessness of this experience—represented in the combination of her modern and ancient dress—must not be lost on us. Even today it is still happening. Maybe even to you. When we offer all that we are to the Saviour, He looks at our heart . . . and sees us through the eyes of forgiveness.

The Cross

I have often wondered who was assigned the task of nailing Christ to the cross. How old was he? What did he look like? Was he reluctant, or was it simply another command to be obeyed? Did he realize shortly after, like the centurion, that "Surely this was a righteous man" (Luke 23:47)? Did he repent?

It occurs to me that I know the man intimately. It was me. In fact, I couldn't become a Christian until I admitted that. Nor can you. So I placed myself at the cross in this painting.

In response to the Saviour's agony, the sky weeps and darkens. Lightning shouts the dreadful news. Mankind's hope fades with the light. What now?

All that's left is for us to turn to the cross. To fall on our knees in repentance. For this is where tragedy turns to triumph.

Resurrection Morning

To the guards on duty that night, maybe it was just another assignment. Another day's pay. Little did they know that the morning to come would be a morning like no other. They would "sleep" while all of Heaven watched the Holy Spirit awaken the Saviour. It was the most pivotal act of all time— the reason Jesus was born. What expectation there must have been among the citizens of heaven!

In this painting you will notice the shadow of the cross falling against the stone. The rays of light emerging from the crack between the stone and the tomb are my interpretation of that incredible moment when the "Light of the world" broke through the world's darkness . . . with life! And above the scene rests a dove—symbol of the Holy Spirit—whose work on this glorious morning is done.

Indeed, the long night was over, and Christ's journey into our hearts had begun.

R. DGreanias